Tips & Techniques for Fabulous Fun

Illustrated by Raffaella, Jessica, and Devin Dowling Photography by F. William Lagaret Text by Jessica Dowling

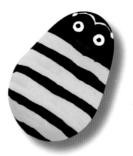

Painting on Rocks: Tips & Techniques for Fabulous Fun Illustrated by Raffaella, Jessica, and Devin Dowling Photography by F. William Lagaret Text by Jessica Dowling

© 2006 by Mud Puddle Books, Inc.

Mud Puddle Books, Inc. 54 W. 21st Street Suite 601 New York, NY 10010 info@mudpuddlebooks.com

ISBN: 1-59412-167-2

All rights reserved. No part of this book may be reproduced or transmitted in any form or by any means, electronic or mechanical, including photocopying, recording, or by any information storage and retrieval system, without permission in writing from the publisher.

Designed by Elsas Design

Printed and bound in China

Contents

- Why Paint Rocks? 4
- Materials 7
- Pet Rocks 8
- Rock Friends 14
- Yummy Rocks 16
- Holiday Rocks 22
- Sporty Rocks 26
- Nature Rocks 28
- Rocks on the Go 34
- Rock Pirates 36
- Rocks in Space 38
- Rock Designs 40
- Chinese Symbols 46

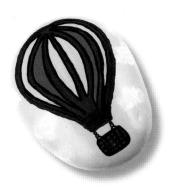

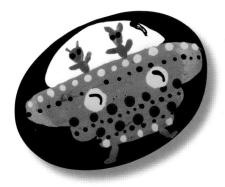

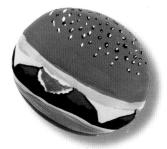

Why Paint Rocks?

Rock painting is an easy and inexpensive way to create your own art! Painting rocks allows you to use your creativity in ways different than when you paint on paper or canvas. By studying the shape of the rock you can imagine all sorts of things that the rock could become.

What can I do with painted rocks?

Painted rocks make unique and expressive indoor or outdoor decorations. Put them on your mantle,

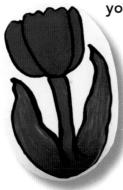

your nightstand, or even use larger ones for bookends. They are great patio decorations, and a few tucked in a flowerpot always look pretty. Don't forget: painted rocks make wonderful gifts, too!

I don't know how to paint!

Rock painting is the perfect medium for beginners. If you mess up, just prime the rock over again and start out fresh. In addition, since the shape of the rock often suggests a form, it is easier for the beginning artist to pick a subject. Painting rocks is great for advanced artists, too! Challenge yourself and see how detailed your rocks can become. When someone mistakenly bites into a rock you've painted to look like a cookie, you're an expert!

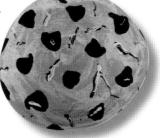

What do I paint on a rock?

Anything! Paint your favorite animal or flower, or create a rock with a sports theme. Paint a letter on each of several rocks, and spell out your name or that of a friend. Paint vegetables or fruits on rocks to decorate a kitchen, or different sea creatures to decorate a bathroom. An apple-painted rock given to a teacher will last much longer than the real thing!

> The possibilities of what to paint are absolutely endless. Use your imagination!

Where can I find rocks?

Most arts and crafts stores sell smooth polished river stones. These have mostly round or oblong shapes; so if you want to find more unique rocks, get outside! Many rocks of varying shapes, sizes and textures can be found at the beach, or near rivers and lakes. If you live in a city, you can try looking for rocks in a park.

Always make sure to have an adult with you when you go out looking for rocks.

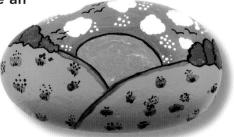

Priming

Because rocks are often dark or bumpy, it is important to prime them before you paint your design. This prepares the rock to be painted on. To prime a rock, simply cover it with a thick coat of white paint and allow it to dry completely. It's okay if the rock's color still shows through; it will get covered up when you paint your design.

Materials

Acrylic Paint. A good basic set of paints would consist of white, black, red, blue, and yellow. You can mix most other colors you might want to use from these. You may, however, wish to invest in some extra paints since colors such as magenta and brown may be difficult to mix on your own. You'll find two-ounce bottles of acrylic craft paint are fairly inexpensive. They work great and cost much less than fine arts acrylics.

Acrylic brushes in several sizes. Consider starting out with a size 6 filbert, a size 4 round, and a size 0 round (for fine details). Try out different brush sizes as you determine your artistic needs.

Clear acrylic glaze to protect rocks that are displayed outside or to give your indoor rocks a brilliant sheen. This glaze comes in aerosol cans or in liquid form to be painted on. Use the liquid form for painting rocks because it adheres better, and you can apply it indoors. A small bottle (around 120 ml) should last a long time.

Toothpicks. These are great for painting tiny details or dots.

A cup of water to clean brushes.

Paper towels for surface cleanup.

Newspaper to lay on top of your work area and protect surfaces.

A pencil to sketch out your design on the rock. A soft pencil works best, as it will show up on the rock better. Instead of a standard #2 pencil, pick up a soft 6B pencil at an art supply store.

Scrap paper to jot down ideas. Always keep some paper with you in case a great idea for a painted rock strikes you when you are on the go!

Pet Rocks

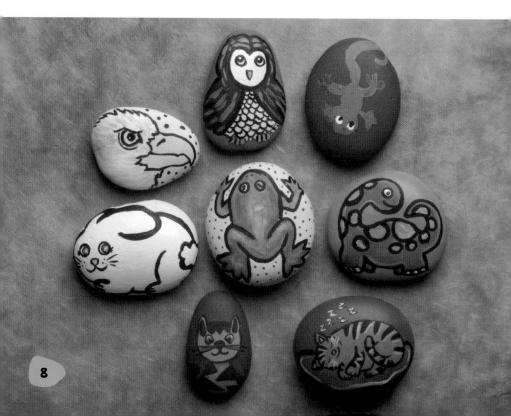

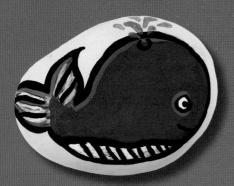

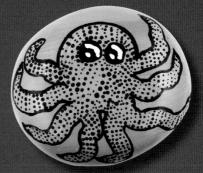

Whale

Octopus

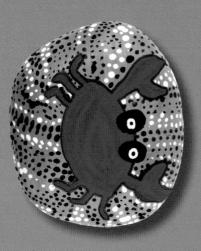

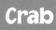

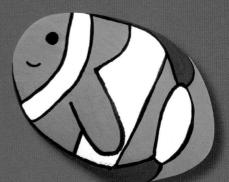

Fish

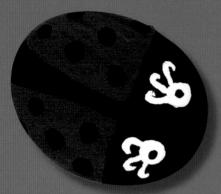

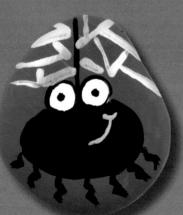

Spider

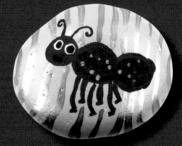

Ant

Ants at a Picnic

Lizard

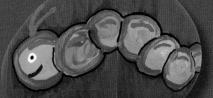

Caterpillar

TIPE

If rocks are dirty or muddy, wash them with warm water and dish soap, then pat dry with paper towels.

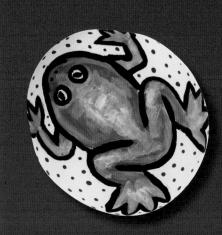

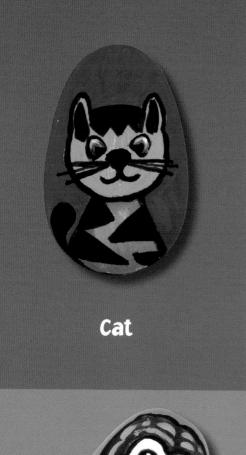

If you'd like, sketch a loose design on a primed rock with a soft pencil before you start painting.

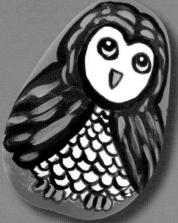

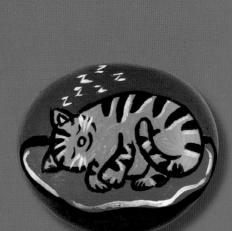

Sleeping Cat

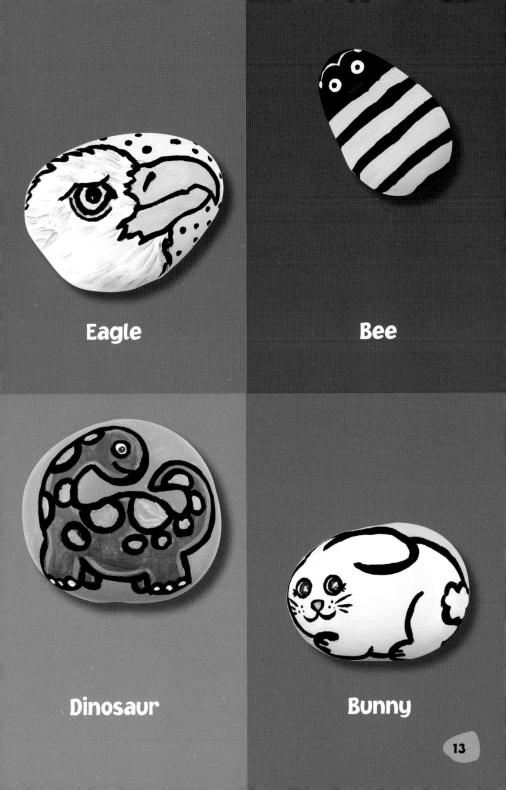

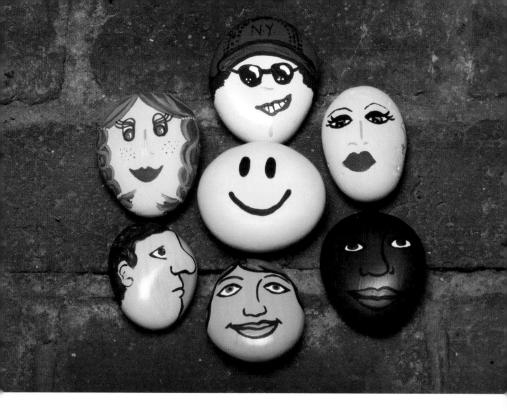

Rock Friends

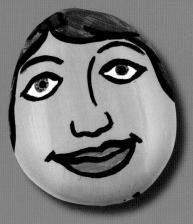

Elizabeth

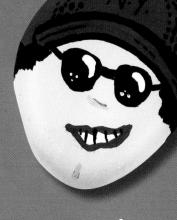

David

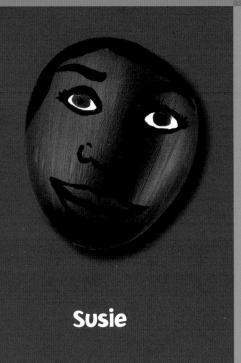

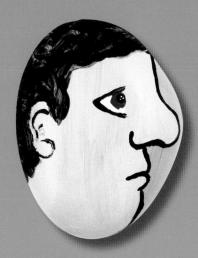

Chris

Yummy Rocks

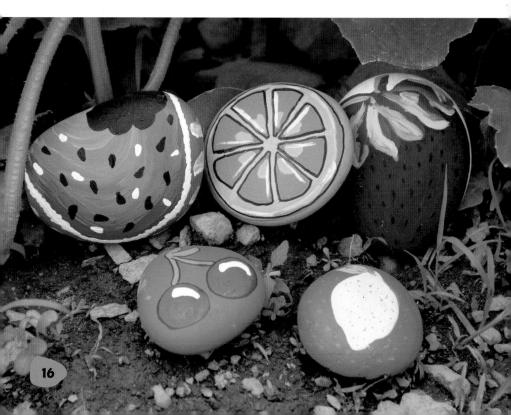

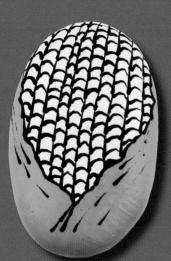

Corn

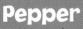

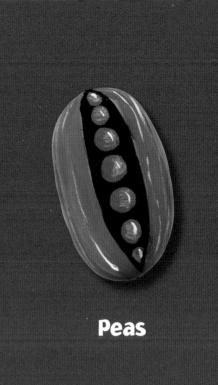

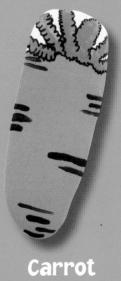

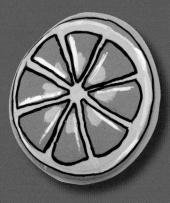

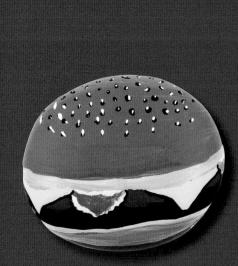

Orange

Cheeseburger

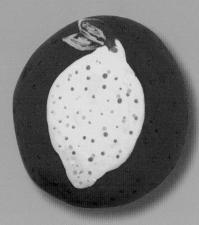

Lemon

Sushi

Pizza

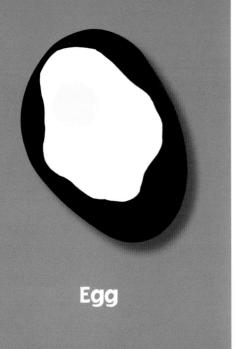

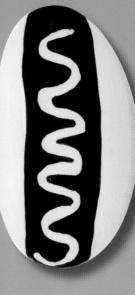

Hot Dog

Make sure to take a break from painting every so often to give your hands and eyes a rest.

A little paint goes a long way! Put only a dab of each color on your palette, you can always add more.

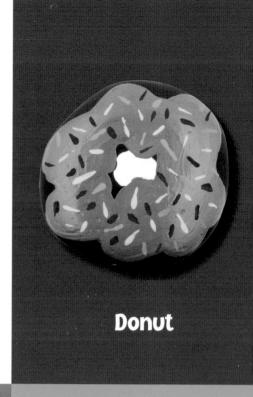

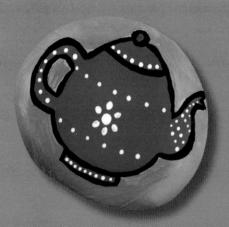

Pot of tea

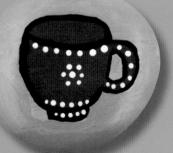

Cup of tea

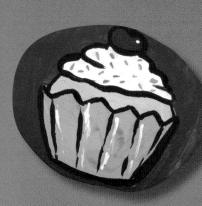

Cupcake

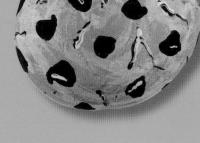

Cookie

The colors of your design will be clearer and more vibrant if you do a good job priming the rock first.

Cherries

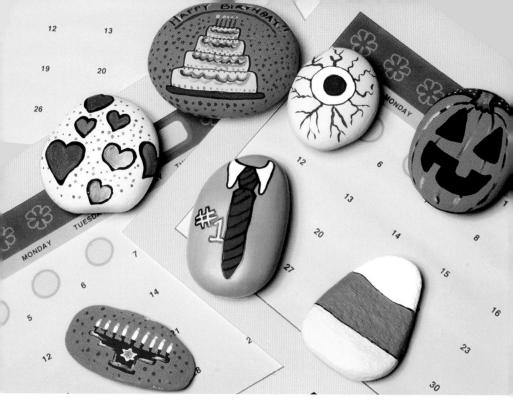

Holiday Rocks

Father's Day

Valentine's Day

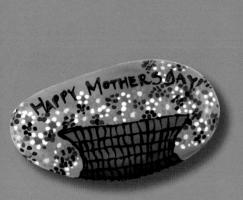

Mother's Day

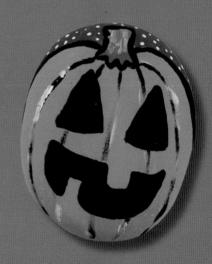

Halloween

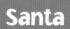

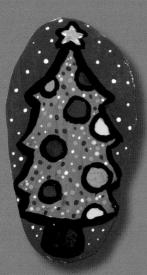

Christmas Tree

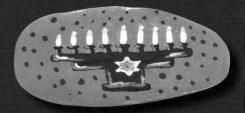

Hannuka Menorah

Stocking

Try to think of creative backgrounds for your subject matter. Don't always use white! Try bright colors, stripes, or even polka dots as a backdrop for your creations.

Easter Egg

Wreath

Sporty Rocks

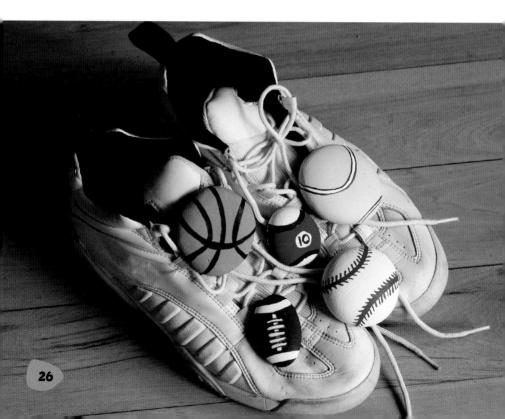

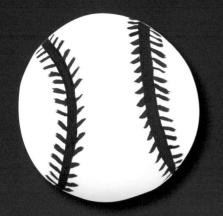

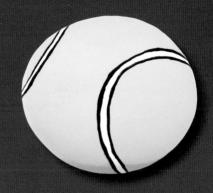

Baseball

Tennis Ball

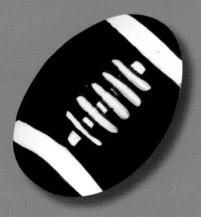

Football

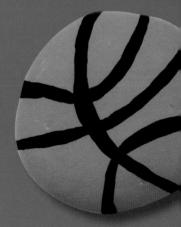

Basketball

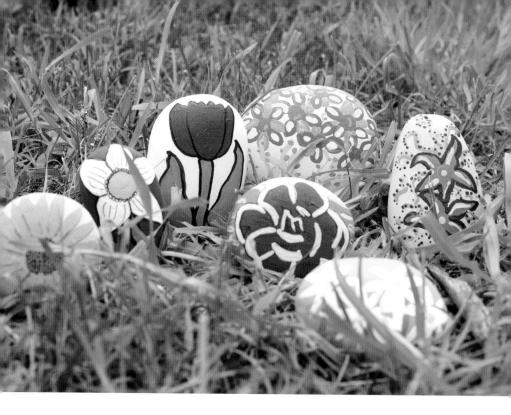

Nature Rocks

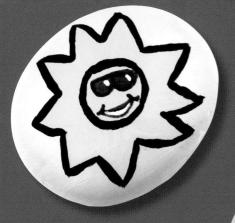

Sun

Rainbow

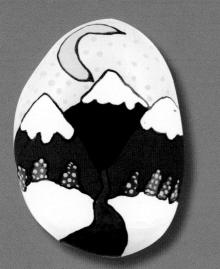

Mountains

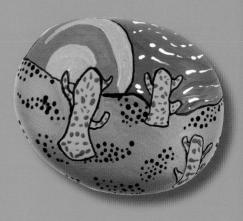

Desert

Fluffy Clouds

TIPI

Experiment using a thin permanent marker on finished, totally dry rocks. Use it to outline objects, or add fine details.

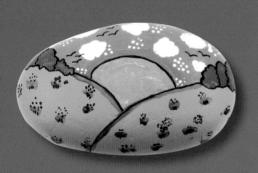

Sunrise

Beach

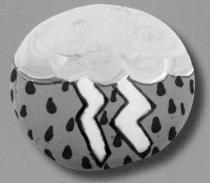

Rain Cloud

Change the water you use to clean your brushes often, to prevent muddy colors.

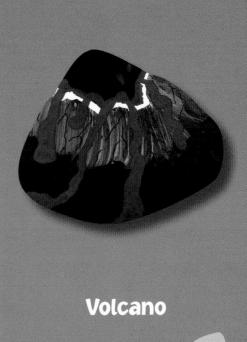

Painted rocks make great paperweights or doorstoppers!

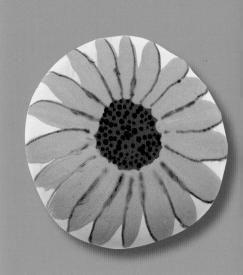

Sunflower

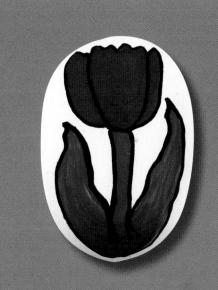

Tulip

Rose

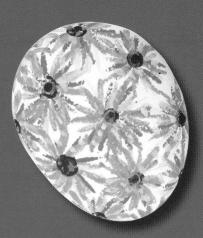

Daisies

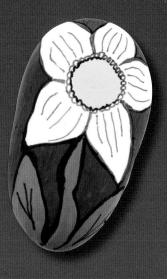

Daffodil

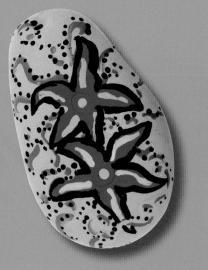

Wildflowers

Use two or more painted rocks to create a composition. For instance, a rock with a tree painted on it, one with a bench, and one with a fountain make an adorable park!

33

Rocks on the Go

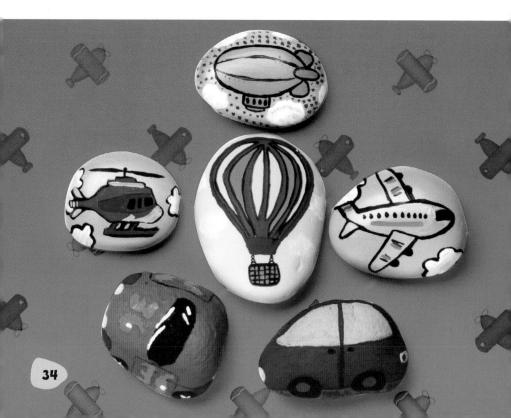

Blimp

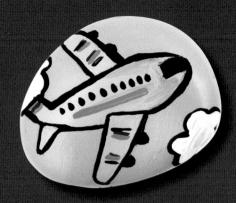

Airplane

Hot Air Balloon

Car

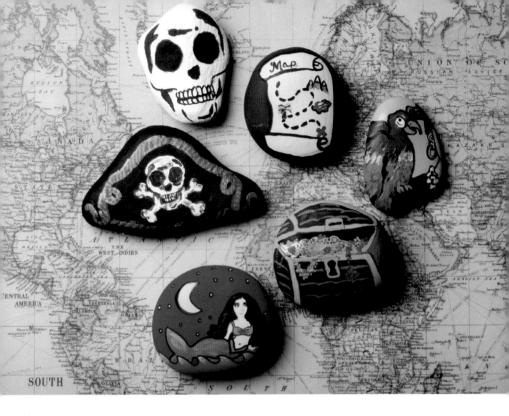

Rock Pirates

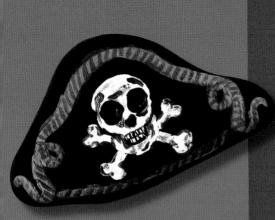

Pirate Hat

Pirate's Parrot

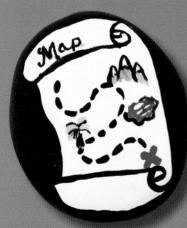

Pirate Map

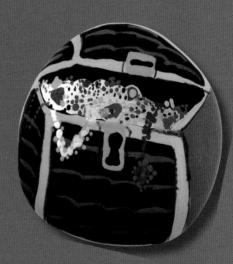

Pirate Treasure

Rocks in Space

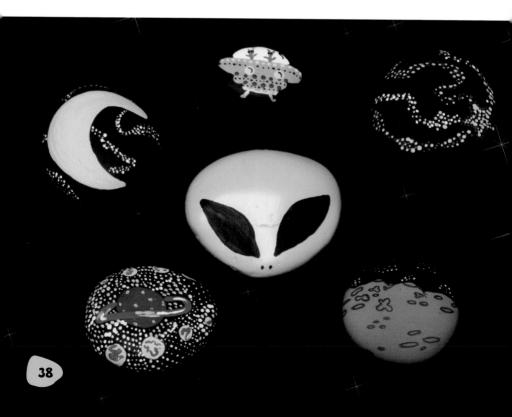

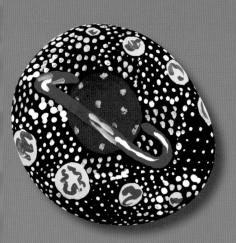

Saturn

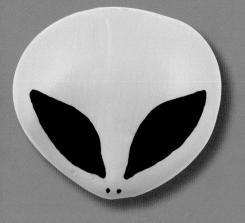

Space Alien

Moonscape

UFO

39

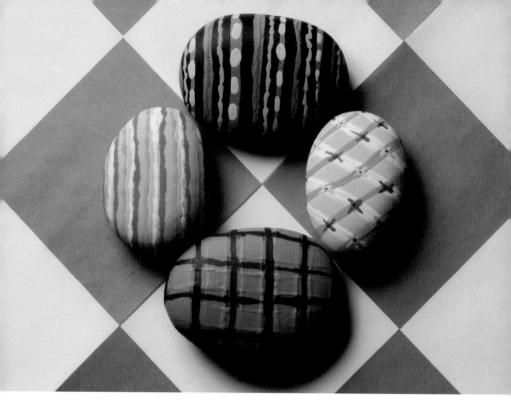

Rock Designs

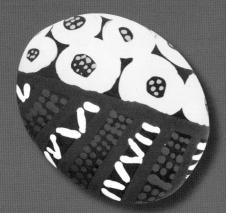

Circles and Lines

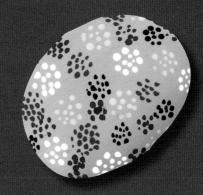

Tiny Dots

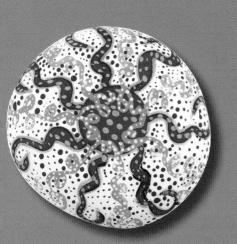

Curly Lines

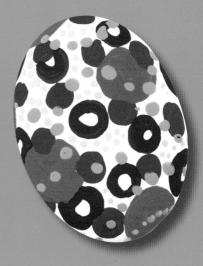

Lots of Circles

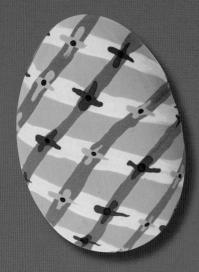

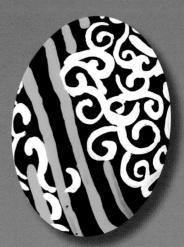

Criss Cross

Swirls and Stripes

Toothpicks are one of the most useful tools for painting rocks. Dipping one in a small amount of paint allows you to create fine details and designs.

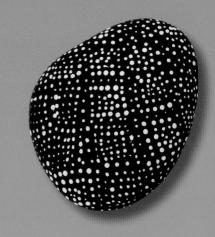

Dot Pattern

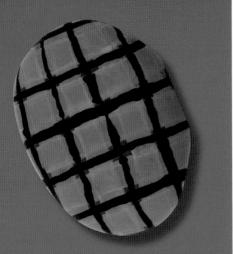

Checkerboard

Good lighting conditions are key! Make sure you are working in bright light. This will allow you to see colors clearly, and keep your eyes from working too hard.

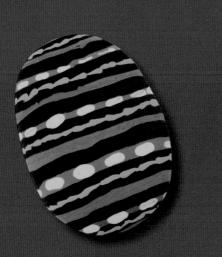

Bright Stripes

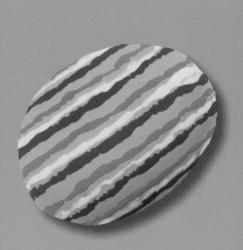

Happy Stripes

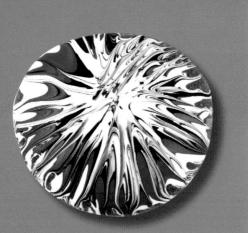

Marble Pattern

To make rocks more brilliant, give them a coat of clear acrylic after they are completely dry.

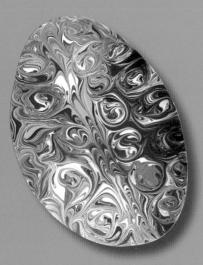

Marble Swirls

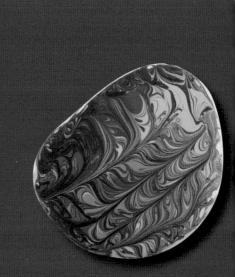

Multicolor Marble

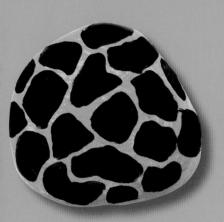

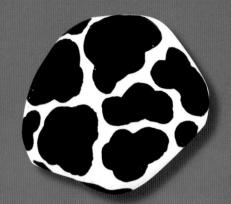

Leopard Print

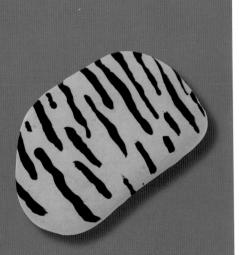

Tiger Print

Cow Print

TIPL

Don't leave brushes in your cup of water! This can cause the bristles and handle of your brush to get ruined. After washing your brushes, lay them on some paper towels to dry until you need them again. Well cared for brushes can last years!

Chinese Symbols

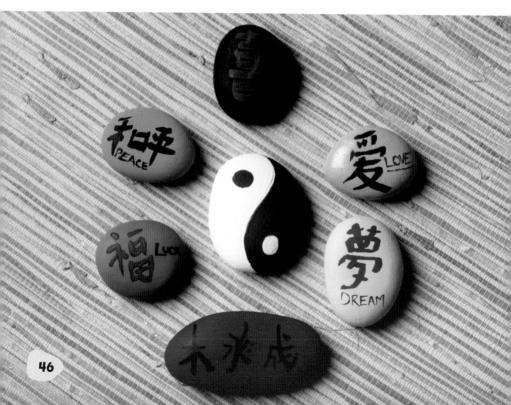

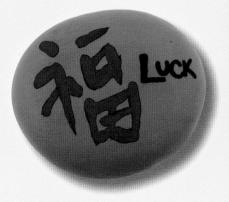

Luck

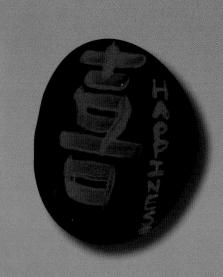

Happiness

PEACE

Peace

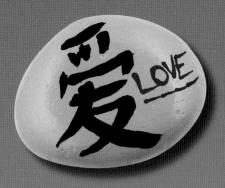

Love